COLOR & PRAY
Psalms

new seasons®
a division of Publications International, Ltd.

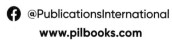

Let's get social!
@Publications_International
@PublicationsInternational
www.pilbooks.com

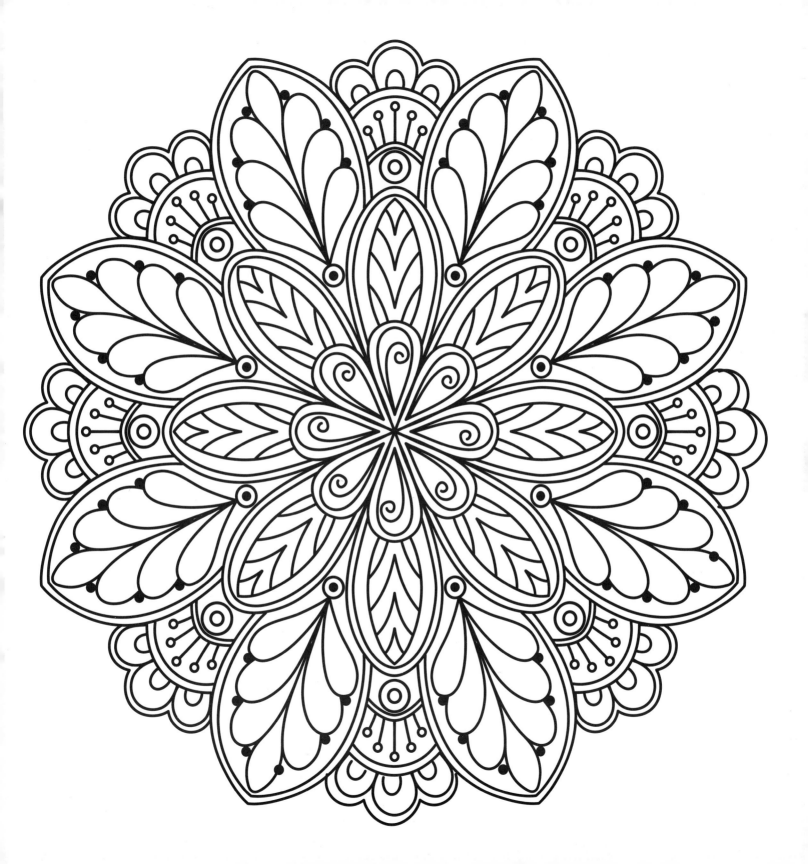

The earth is the Lord's, and the fulness thereof;
the world, and they that dwell therein.
For he hath founded it upon the seas,
and established it upon the floods.

Psalm 24:1–2

Keep me as the
apple of the eye,
hide me under the
shadow of thy wings.

Psalm 17:8

The Lord will command his lovingkindness in the day time,
and in the night his song shall be with me,
and my prayer unto the God of my life.

Psalm 42:8

They that sow in tears shall reap in joy.
He that goeth forth and weepeth,
bearing precious seed,
shall doubtless come again with rejoicing,
bringing his sheaves with him.

Psalm 126:5–6

Give ear, O Lord,
unto my prayer;
and attend to the
voice of my supplications.
In the day of my trouble
I will call upon thee:
for thou wilt answer me.

Psalm 86:6–7

Make a joyful noise unto the Lord, all the earth:
make a loud noise, and rejoice, and sing praise.
Sing unto the Lord with the harp; with the harp,
and the voice of a psalm. With trumpets and sound
of cornet make a joyful noise before the Lord, the King.
Let the sea roar, and the fulness thereof; the world,
and they that dwell therein. Let the floods clap their
hands: let the hills be joyful together before the Lord;
for he cometh to judge the earth: with righteousness
shall he judge the world, and the people with equity.

Psalm 98:4–9

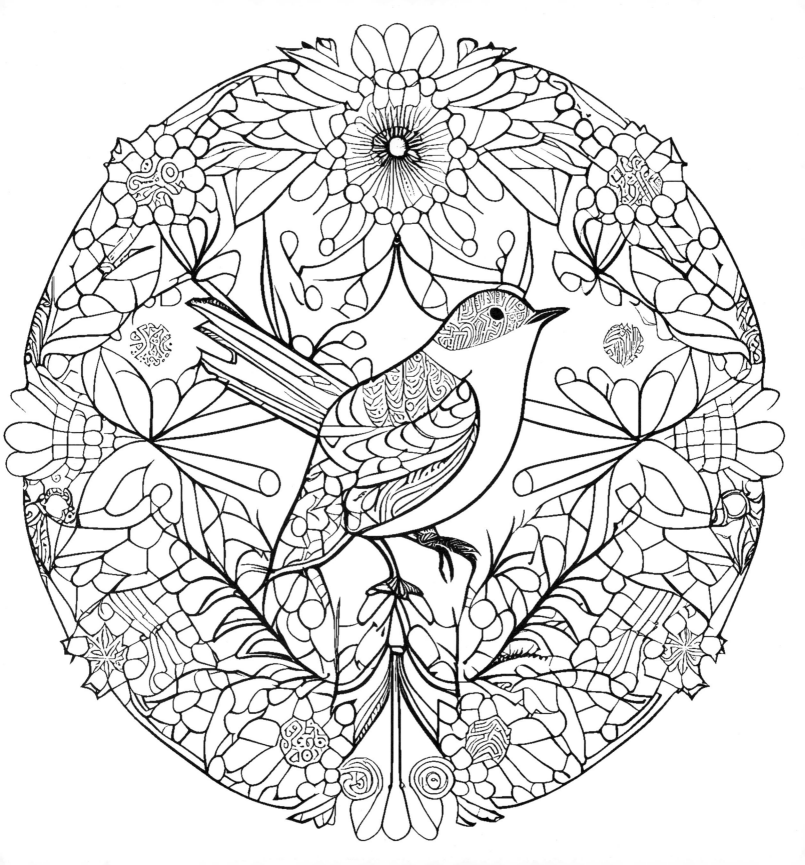

As the heaven is high above the earth,
so great is his mercy toward them that fear him.
As far as the east is from the west, so far hath he
removed our transgressions from us.

Psalm 103:11–12

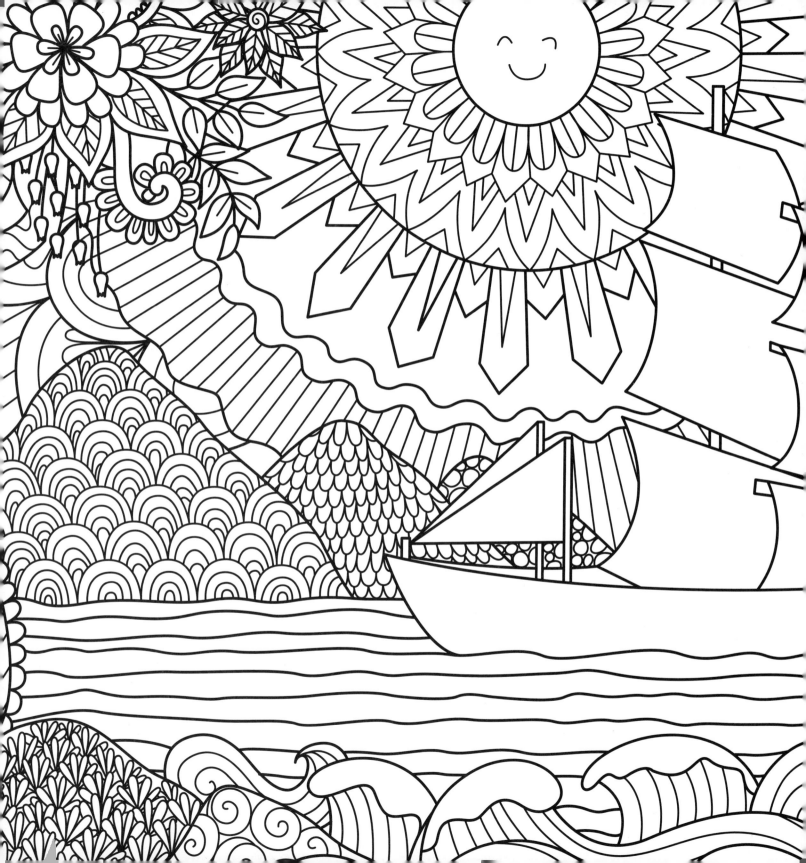

Sing unto the Lord with thanksgiving;
sing praise upon the harp unto our God:
Who covereth the heaven with clouds, who
prepareth rain for the earth, who maketh grass to
grow upon the mountains. He giveth to the beast
his food, and to the young ravens which cry.

Psalm 147:7–9

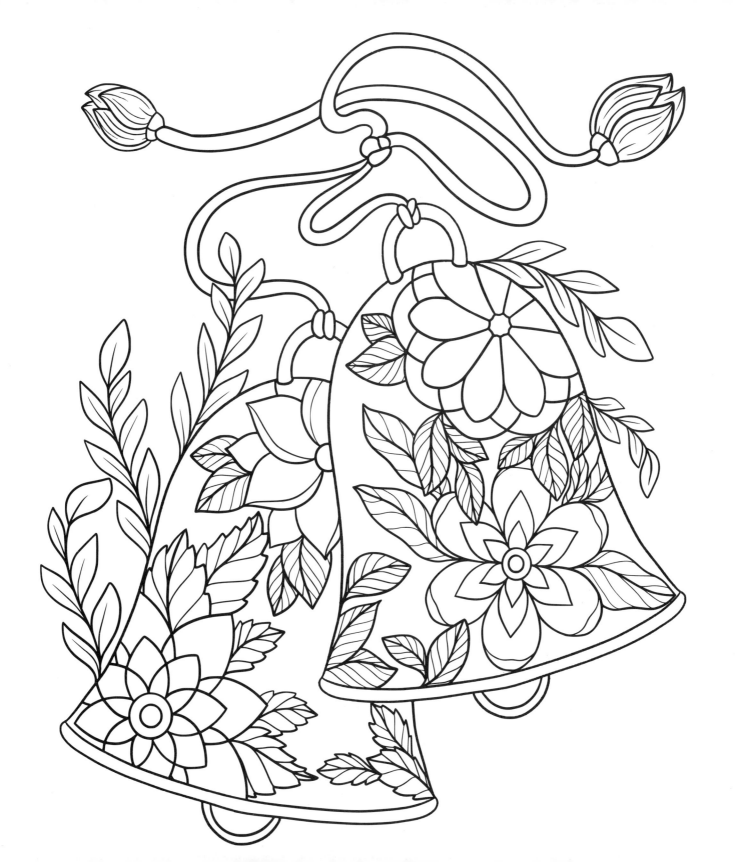

Hear my cry, O God; attend unto my prayer.
From the end of the earth will I cry unto thee,
when my heart is overwhelmed: lead me to the rock
that is higher than I. For thou hast been a shelter for me,
and a strong tower from the enemy.

Psalm 61:1–3

My voice shalt thou hear in the morning, O Lord;
in the morning will I direct my prayer unto thee, and will look up.

Psalm 5:3

But thou, O Lord, art a shield for me;
my glory, and the lifter up of mine head.

Psalm 3:3

Blessed is the man that walketh
not in the counsel of the ungodly,
nor standeth in the way of sinners,
nor sitteth in the seat of the scornful.
But his delight is in the law of the Lord;
and in his law doth he meditate day and night.
And he shall be like a tree planted by
the rivers of water, that bringeth forth
his fruit in his season; his leaf also
shall not wither; and whatsoever
he doeth shall prosper.

Psalm 1:1–3

From the rising of the sun
unto the going down of the
same the Lord's name is
to be praised.

Psalm 113:3

Return unto thy rest, O my soul;
for the Lord hath dealt bountifully
with thee. For thou hast delivered
my soul from death, mine eyes
from tears, and my feet from
falling. I will walk before the
Lord in the land of the living.

Psalm 116:7–9

If I take the wings of the morning, and dwell in the uttermost parts of the sea; Even there shall thy hand lead me, and thy right hand shall hold me.

Psalm 139:9–10

For a day in thy courts is better than a
thousand. I had rather be a doorkeeper
in the house of my God, than to dwell
in the tents of wickedness. For the Lord
God is a sun and shield: the Lord will give
grace and glory: no good thing will he
withhold from them that walk uprightly.

Psalm 84:10–11

I will bless the Lord at all times: his praise shall continually be in my mouth. My soul shall make her boast in the Lord: the humble shall hear thereof, and be glad. O magnify the Lord with me, and let us exalt his name together.

Psalm 34:1–3

The Lord is my strength and my shield;
my heart trusted in him, and I am helped:
therefore my heart greatly rejoiceth;
and with my song will I praise him.

Psalm 28:7

Behold, God is mine helper:
the Lord is with them that uphold my soul.

Psalm 54:4

Sing aloud unto God our strength:
make a joyful noise unto the God of Jacob.
Take a psalm, and bring hither the timbrel,
the pleasant harp with the psaltery.

Psalm 81:1–2

Glory ye in his holy name:
let the heart of them rejoice that seek the Lord.
Seek the Lord, and his strength: seek his face evermore.

Psalm 105:3–4

Hear my prayer, O Lord, and let my cry come unto thee.
Hide not thy face from me in the day when I am in trouble; incline
thine ear unto me: in the day when I call answer me speedily.

Psalm 102:1–2

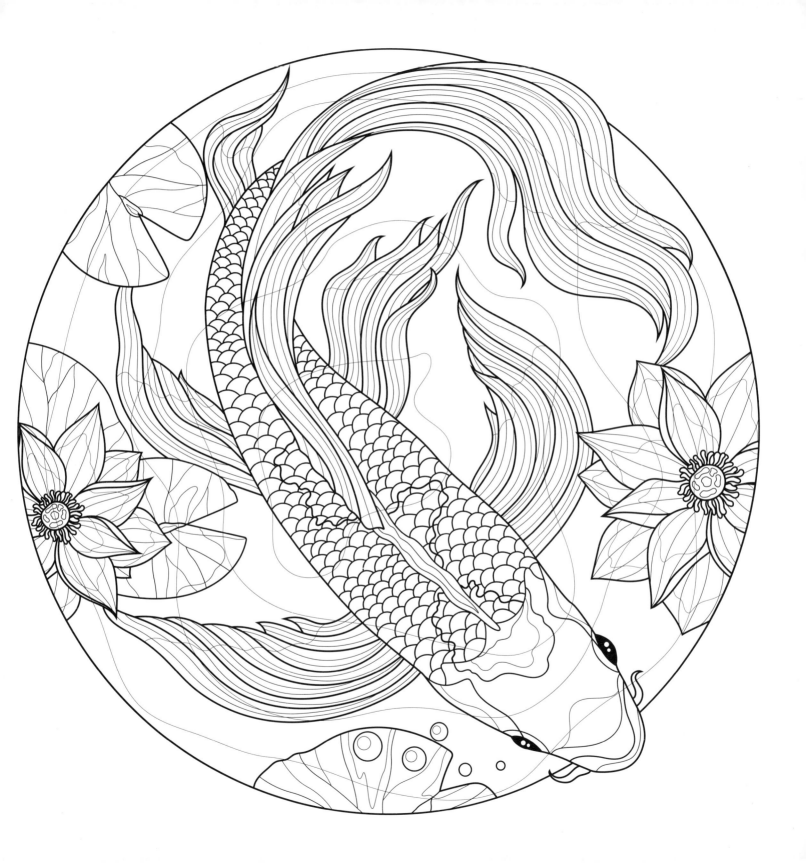

Truly my soul waiteth upon God: from him cometh my salvation.
He only is my rock and my salvation; he is my defence;
I shall not be greatly moved.

Psalm 62:1–2

I will praise thee, O Lord, with my whole heart; I will shew forth
all thy marvellous works. I will be glad and rejoice in thee:
I will sing praise to thy name, O thou most High.

Psalm 9:1–2

I will sing unto the Lord, because he
hath dealt bountifully with me.

Psalm 13:6

The Lord is my shepherd; I shall not want. He maketh
me to lie down in green pastures: he leadeth me
beside the still waters. He restoreth my soul: he leadeth
me in the paths of righteousness for his name's sake.

Psalm 23:1–3

I will also praise thee with the psaltery,
even thy truth, O my God:
unto thee will I sing with the harp,
O thou Holy One of Israel.

Psalm 71:22

The Lord reigneth, he is clothed with majesty; the Lord is clothed with strength, wherewith he hath girded himself: the world also is stablished, that it cannot be moved.

Psalm 93:1

O give thanks unto the Lord, for he is good:
for his mercy endureth for ever.

Psalm 107:1

Though I walk in the midst of trouble, thou wilt revive me:
thou shalt stretch forth thine hand against the wrath
of mine enemies, and thy right hand shall save me.

Psalm 138:7

I wait for the Lord, my soul doth wait,
and in his word do I hope. My soul
waiteth for the Lord more than they that
watch for the morning: I say, more than
they that watch for the morning.

Psalm 130:5–6

Behold, how good and how pleasant it is for brethren to dwell together in unity!

Psalm 133:1

I cried unto thee, O Lord: I said,
Thou art my refuge and my portion
in the land of the living.

Psalm 142:5

Great is the Lord, and greatly to be praised;
and his greatness is unsearchable.
One generation shall praise thy works to another,
and shall declare thy mighty acts.

Psalm 145:3–4

For he shall give his angels charge over
thee, to keep thee in all thy ways.
They shall bear thee up in their hands,
lest thou dash thy foot against a stone.

Psalm 91:11–12

So we thy people and sheep of thy pasture
will give thee thanks for ever: we will shew
forth thy praise to all generations.

Psalm 79:13

Sing praises to God, sing praises:
sing praises unto our King, sing praises.
For God is the King of all the earth:
sing ye praises with understanding.

Psalm 47:6–7

Lord, who shall abide in thy tabernacle?
who shall dwell in thy holy hill? He that walketh
uprightly, and worketh righteousness,
and speaketh the truth in his heart.

Psalm 15:1–2

Make a joyful noise unto God,
all ye lands: Sing forth the honour
of his name: make his praise glorious.

Psalm 66:1–2

Yea, the sparrow hath found an house,
and the swallow a nest for herself,
where she may lay her young, even thine altars,
O Lord of hosts, my King, and my God.

Psalm 84:3

Light is sown for the righteous, and gladness for the upright in heart. Rejoice in the Lord, ye righteous; and give thanks at the remembrance of his holiness.

Psalm 97:11–12

Turn us again, O Lord God of hosts, cause thy
face to shine; and we shall be saved.

Psalm 80:19

I will lift up mine eyes unto the hills, from whence cometh my help. My help cometh from the Lord, which made heaven and earth.

Psalm 121:1–2

Praise ye the Lord. Praise ye the name of the Lord;
praise him, O ye servants of the Lord.

Psalm 135:1

I will both lay me down in peace, and sleep:
for thou, Lord, only makest me dwell in safety.

Psalm 4:8

Thou art my hiding place; thou shalt preserve
me from trouble; thou shalt compass me
about with songs of deliverance.

Psalm 32:7

Let every thing that hath breath praise the Lord.
Praise ye the Lord.

Psalm 150:6

Lord, I cry unto thee: make haste unto me;
give ear unto my voice, when I cry unto thee.
Let my prayer be set forth before thee as
incense; and the lifting up of my hands as
the evening sacrifice.

Psalm 141:1–2

The fear of the Lord is the beginning of wisdom:
a good understanding have all they that do his
commandments: his praise endureth for ever.

Psalm 111:10

Be thou exalted, O God, above the heavens:
and thy glory above all the earth.

Psalm 108:5

Know ye that the Lord he is God:
it is he that hath made us, and not we
ourselves; we are his people, and the
sheep of his pasture.

Psalm 100:3

The pastures are clothed with flocks;
the valleys also are covered over with
corn; they shout for joy, they also sing.

Psalm 65:13

Then said I, Lo, I come:
in the volume of the book
it is written of me,
I delight to do thy will,
O my God: yea,
thy law is within my heart.

Psalm 40:7–8

But I am like a green olive tree in the house of God:
I trust in the mercy of God for ever and ever.

Psalm 52:8

Blessed be the Lord, who daily loadeth us
with benefits, even the God of our salvation.

Psalm 68:19

Before the mountains were brought forth,
or ever thou hadst formed the earth and the world,
even from everlasting to everlasting, thou art God.

Psalm 90:2

Truth shall spring out of the earth;
and righteousness shall look down from heaven.

Psalm 85:11

Unto thee, O God, do we give thanks,
unto thee do we give thanks: for that thy name
is near thy wondrous works declare.

Psalm 75:1

Because thy lovingkindness is better than life,
my lips shall praise thee. Thus will I bless thee
while I live: I will lift up my hands in thy name.

Psalm 63:3–4

My heart is fixed, O God, my heart is fixed:
I will sing and give praise. Awake up, my glory;
awake, psaltery and harp: I myself will awake early.

Psalm 57:7–8

The Lord is my light and my salvation;
whom shall I fear? the Lord is the strength
of my life; of whom shall I be afraid?

Psalm 27:1

The voice of the Lord is upon the waters:
the God of glory thundereth: the Lord is
upon many waters.

Psalm 29:3

The mighty God, even the Lord, hath spoken,
and called the earth from the rising of the sun
unto the going down thereof.

Psalm 50:1